How to Draw

Kawaii

In Simple Steps

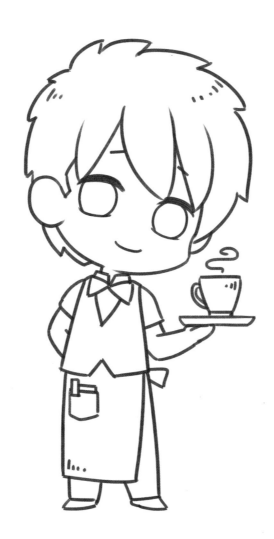

First published in 2020

Search Press Limited
Wellwood, North Farm Road,
Tunbridge Wells, Kent TN2 3DR

Reprinted 2021 (twice), 2022, 2023 (twice), 2024

ISBN: 978-1-78221-890-6

You are invited to visit the author's website:
www.liyishan.com

MIX
Paper | Supporting
responsible forestry
FSC® C012521

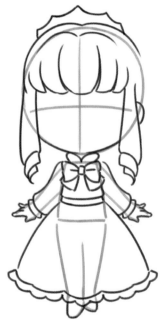

Dedication
To my daughter Amelia: you are the
most Kawaii girl in the world.

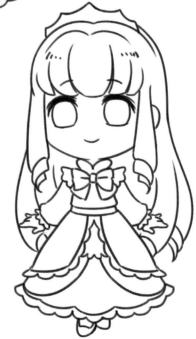

Illustrations

Schoolgirl 5

Café waiter 6

Scientist 7

Witch 8

Princess 9

Cat and kittens 10

Dog 11

Lion 12

Snow leopard 13

Seal 14

Fox 15

Rabbit 16

Bird 17

Whale 18

Popsicle 19

Ice cream cone 20

Cupcake 21

Doughnut 22

Hamburger 23

Sliced bread 24

Hot dog 25

Macarons 26

Old TV 27

Electric kettle 28

Vacuum cleaner 29

Toaster 30

Car 31

Marker pen 32

How to Draw
Kawaii

In Simple Steps

Yishan Li

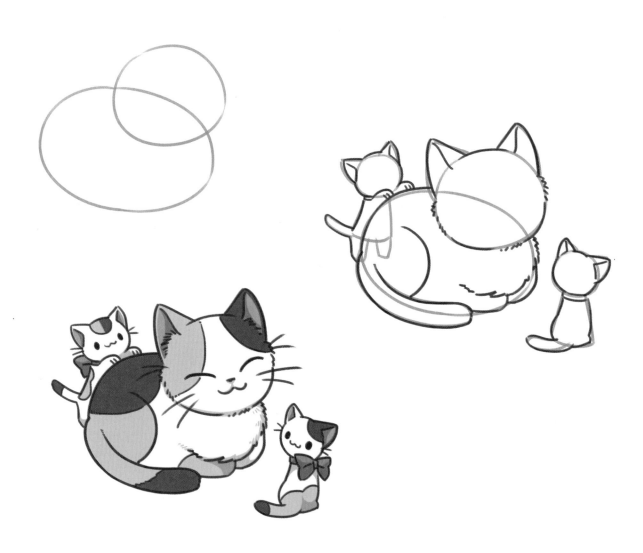

Search Press

Introduction

If you have watched anime or read Manga books, you probably already know the word 'kawaii'. In Japanese, kawaii means cute, adorable or loveable, and it is a massive part of Japanese culture. In Japan, people put kawaii designs on almost anything, from everyday products like a pencil or dress to buildings, trains and planes. So if you love all things kawaii, with a little help from this simple-to-follow book, you can draw everything kawaii yourself!

In this book, there are twenty-eight finished images including chibi (miniature) characters, animals, food and everyday objects. Each of them has eight steps to guide you through the whole drawing process. They all start with very simple shapes, then gradually build up more shapes and details. I use different colours to indicate new strokes added in each new step. The first shape is always in blue, then new shapes added on will be in pink; after that, black lines are used to actually draw the image itself, then the final image is fully coloured to show you the completed picture.

When you practise, all you need is paper, a pencil and an eraser. I prefer normal copying paper to special art paper because it's cheaper and easy to draw on. You can choose any soft graphite pencil, preferably 2B. The eraser can just be the one you normally use at home or school.

When drawing the initial shapes, start with very light strokes, then when you are adding more details, you can use slightly more solid lines. This way you can see your final image clearly rather than losing it among all the messy lines.

Once you are more confident with your black and white pencil drawings, you can add ink and colours. You need an ink pen and colouring materials. The ink pen can be any black waterproof gel pen. Try it first on a spare piece of paper to make sure it doesn't smudge.

When you have inked in the drawing, you can clear away all the pencil lines with the eraser. For colouring pens, I prefer water-based dye ink pens, but if you would rather use something easy to find at home, you can also use watercolour or ordinary coloured pencils.

The most important thing I hope you will learn from this book is to be creative. Everything can be kawaii if you add just a bit of creativity!

Happy Drawing!

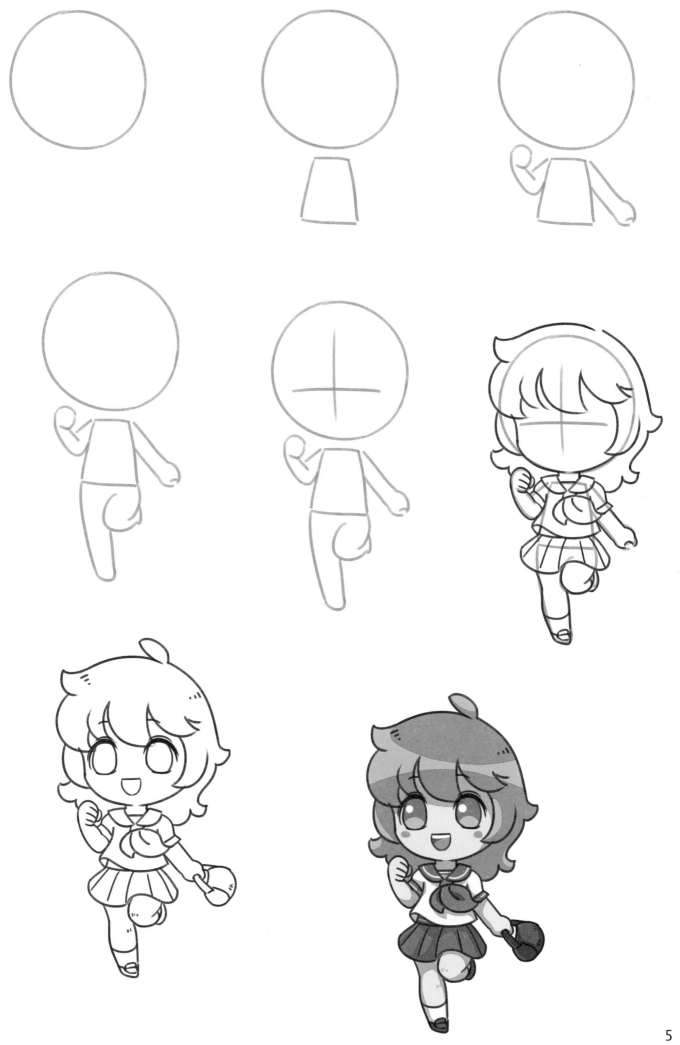

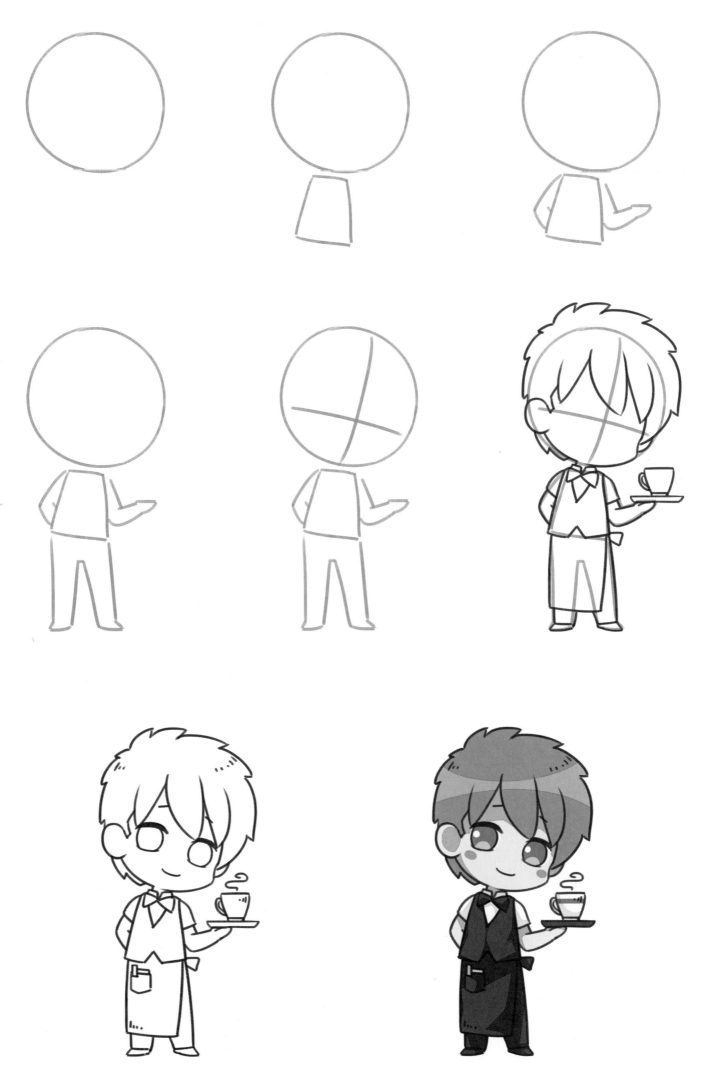

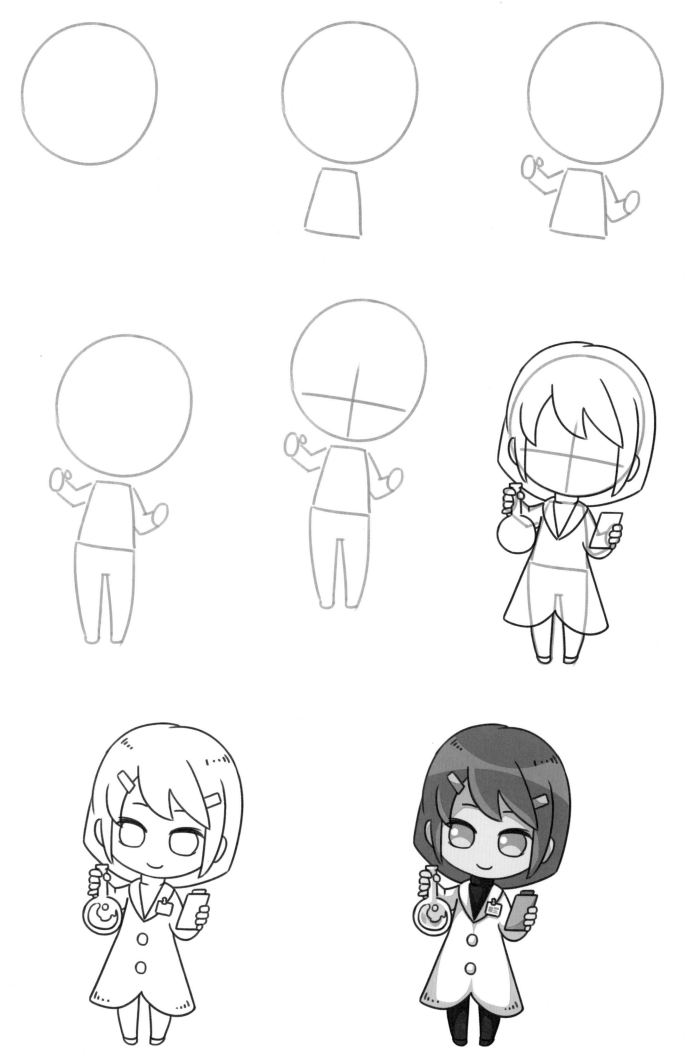

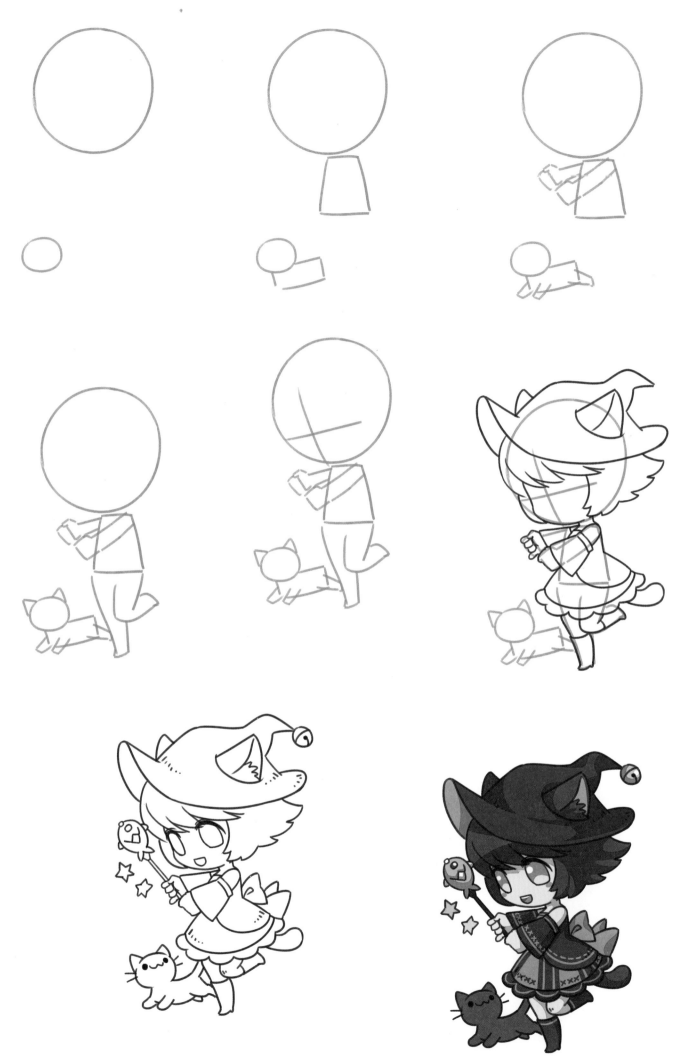

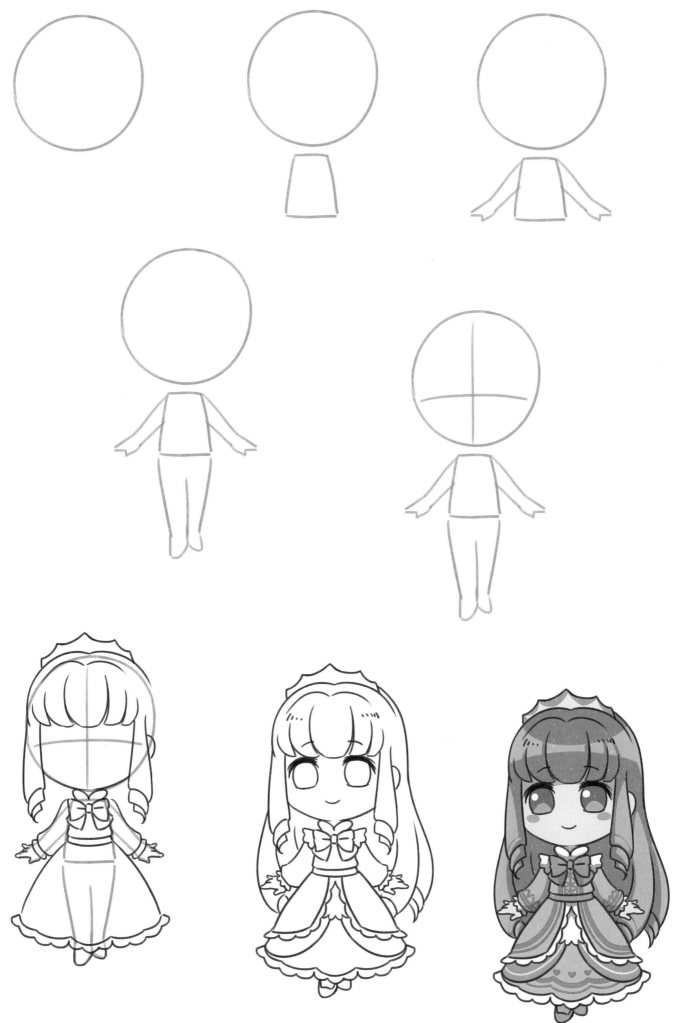

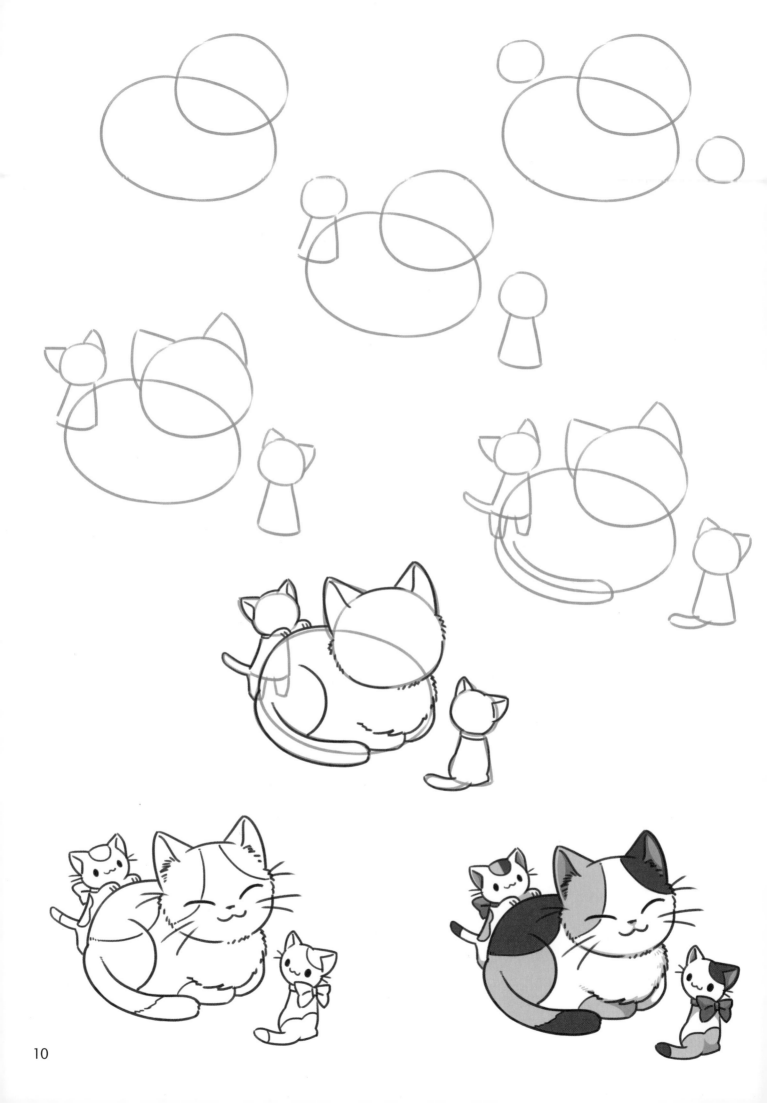

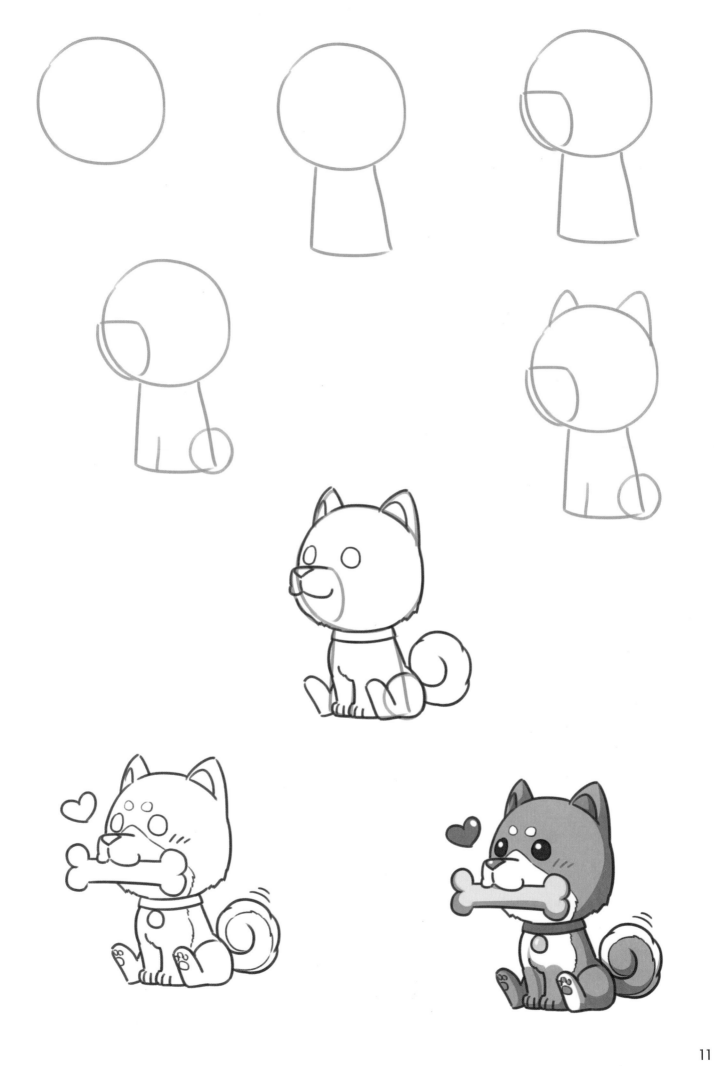

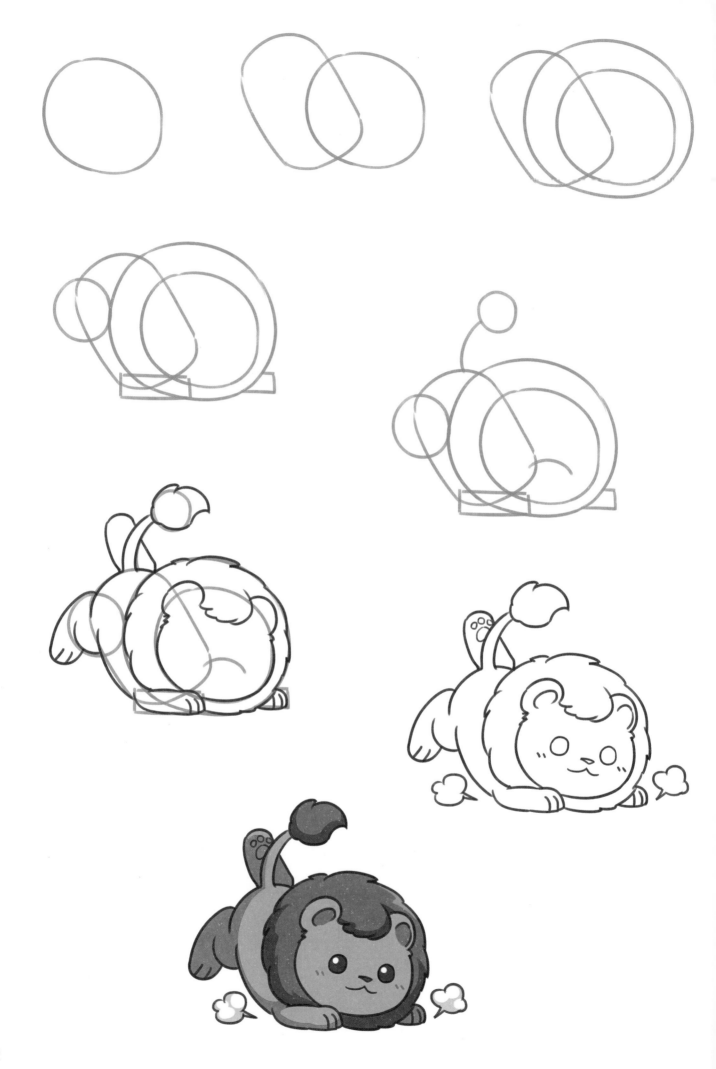

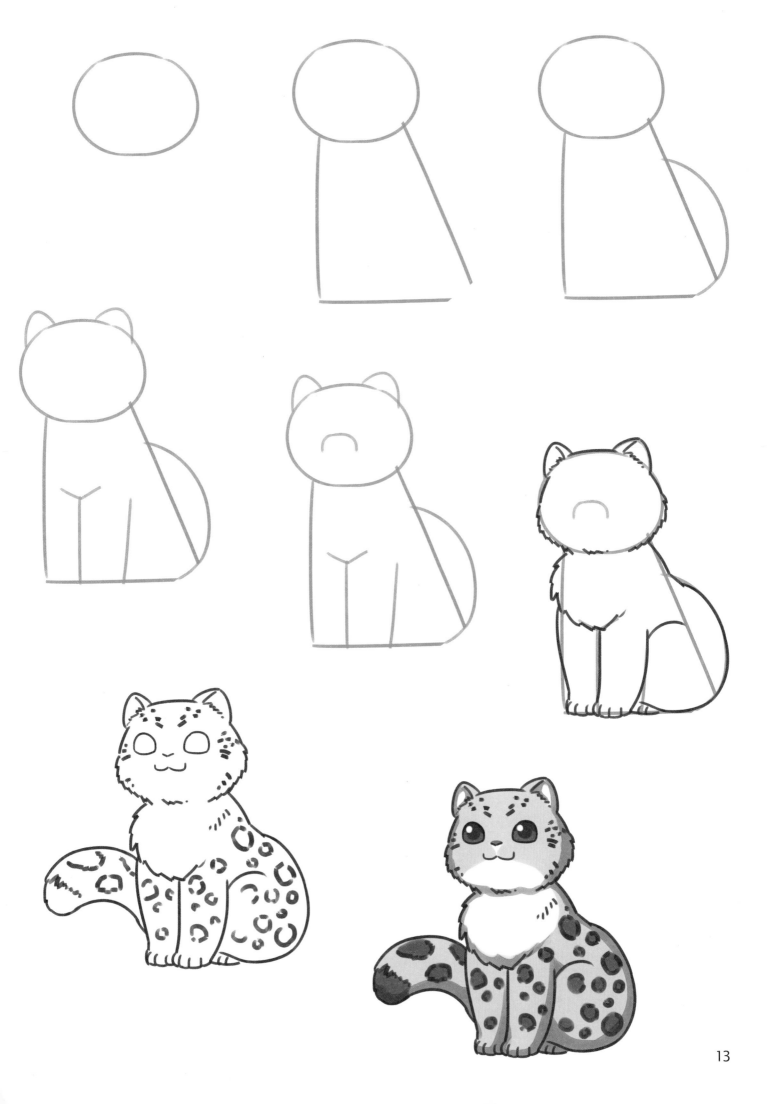

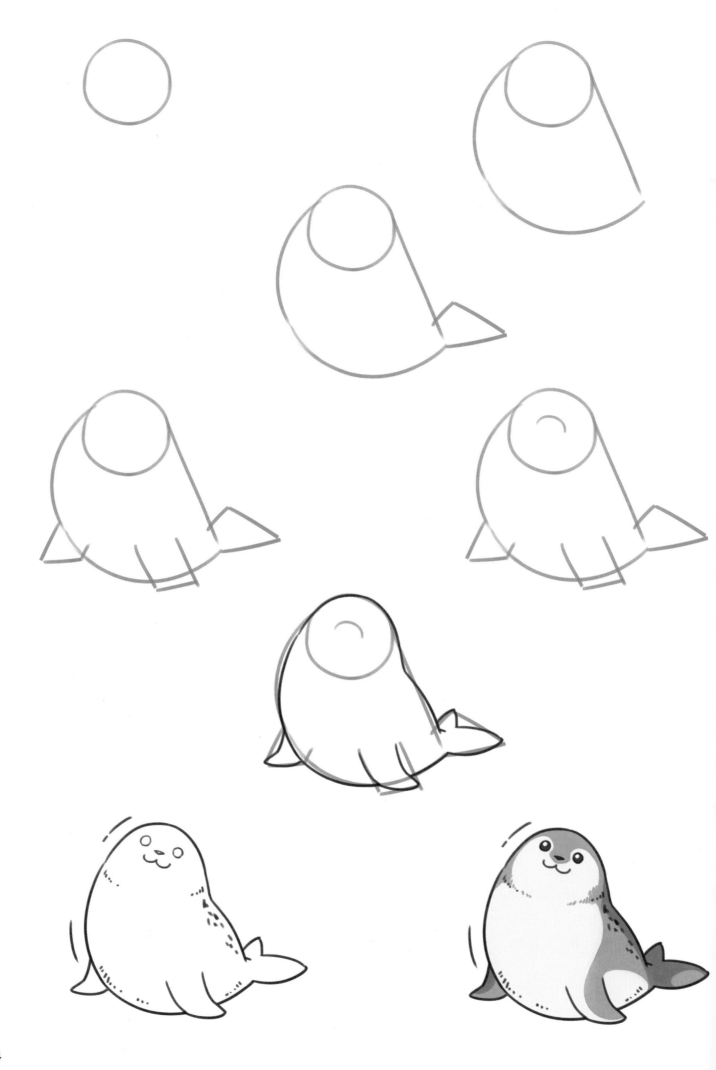

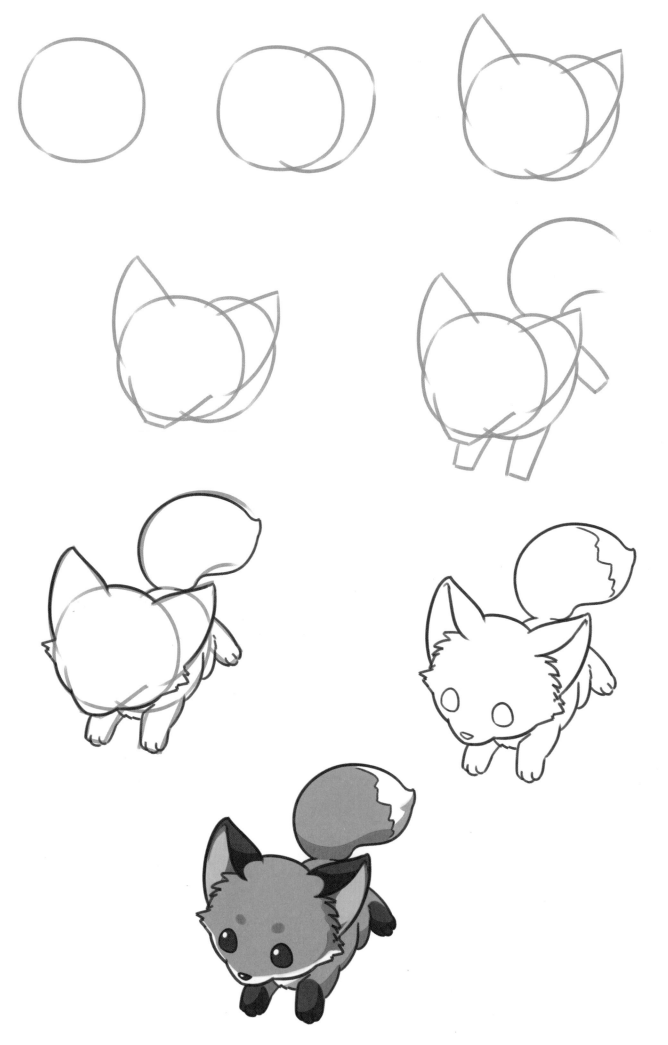

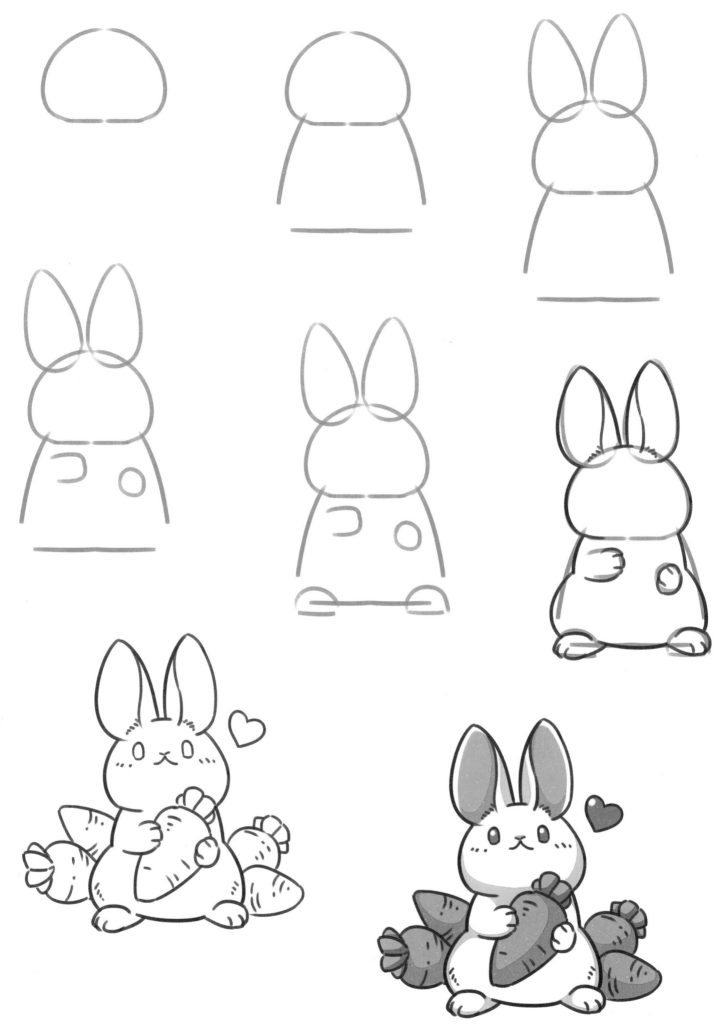

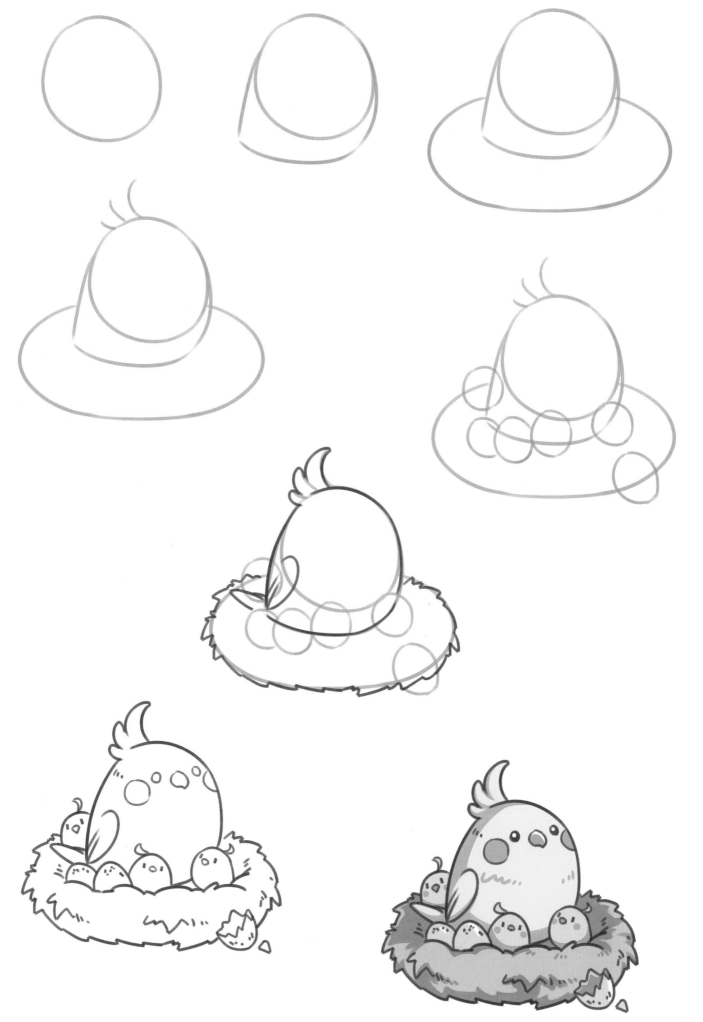

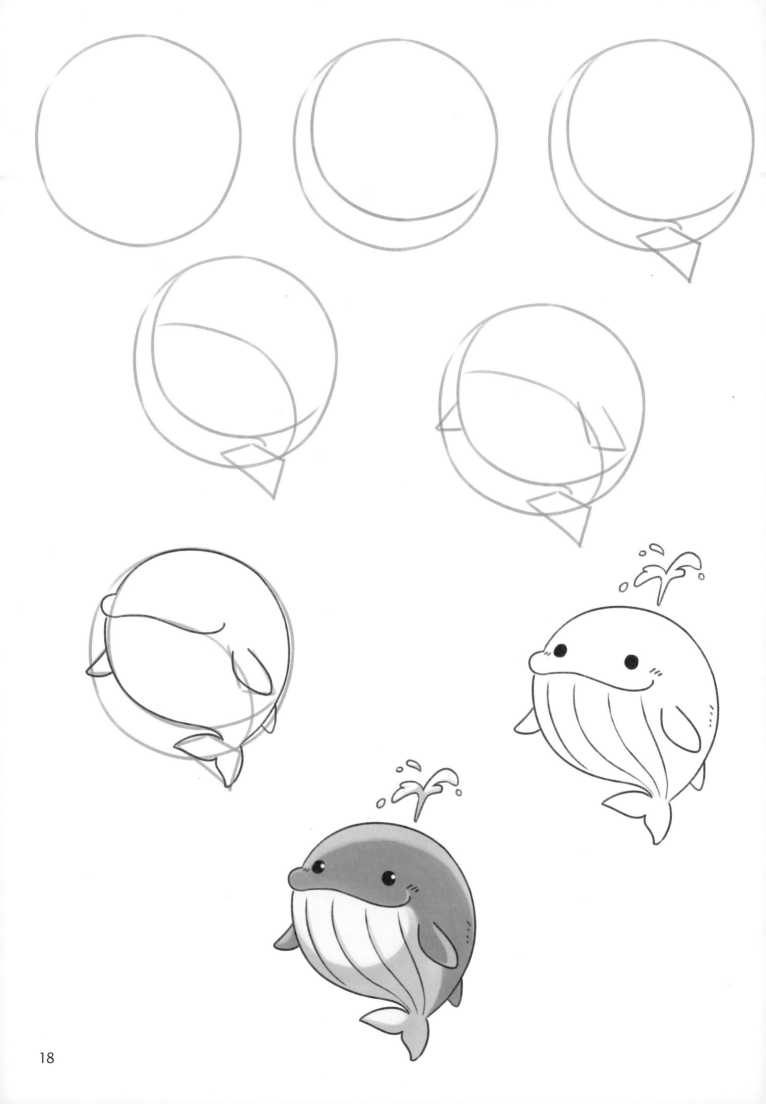

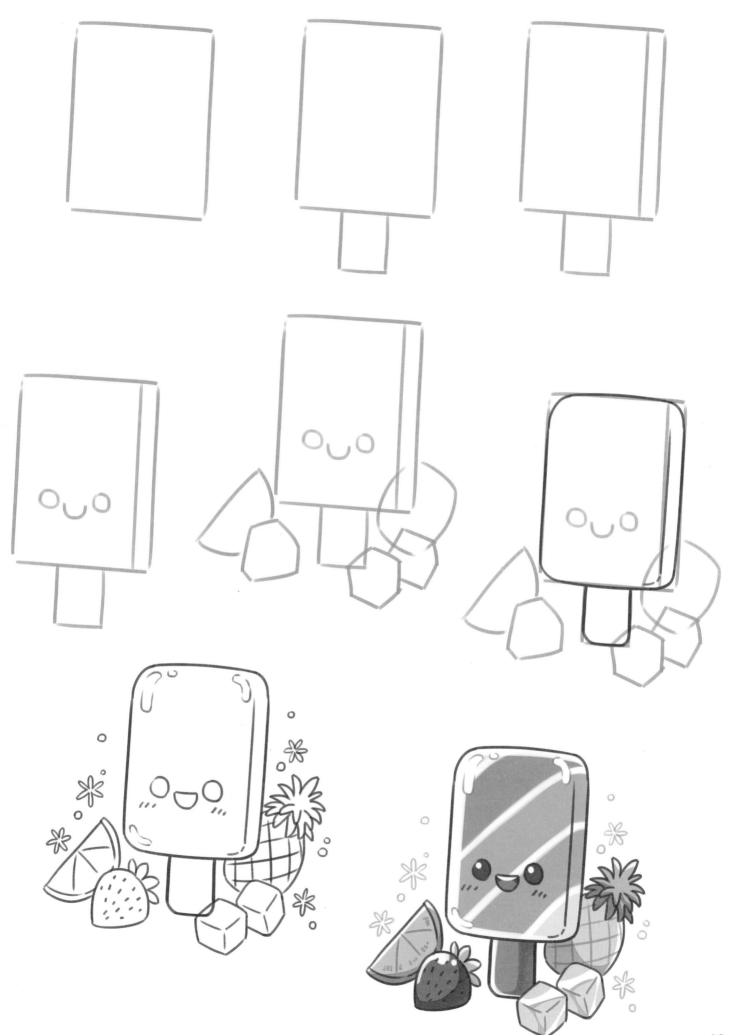

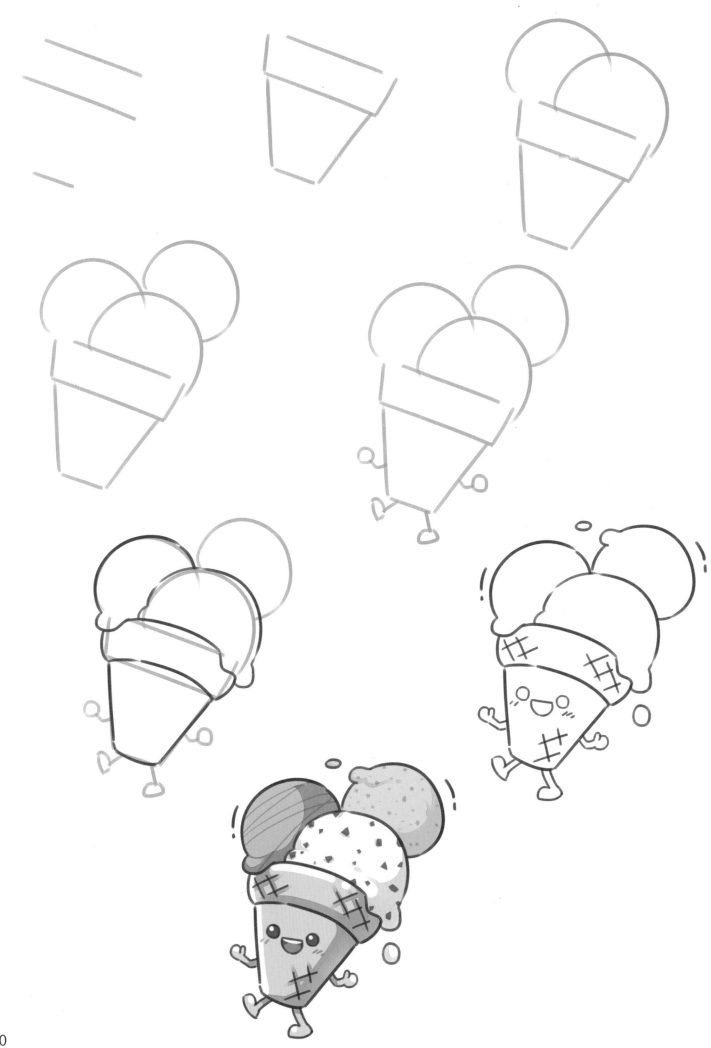

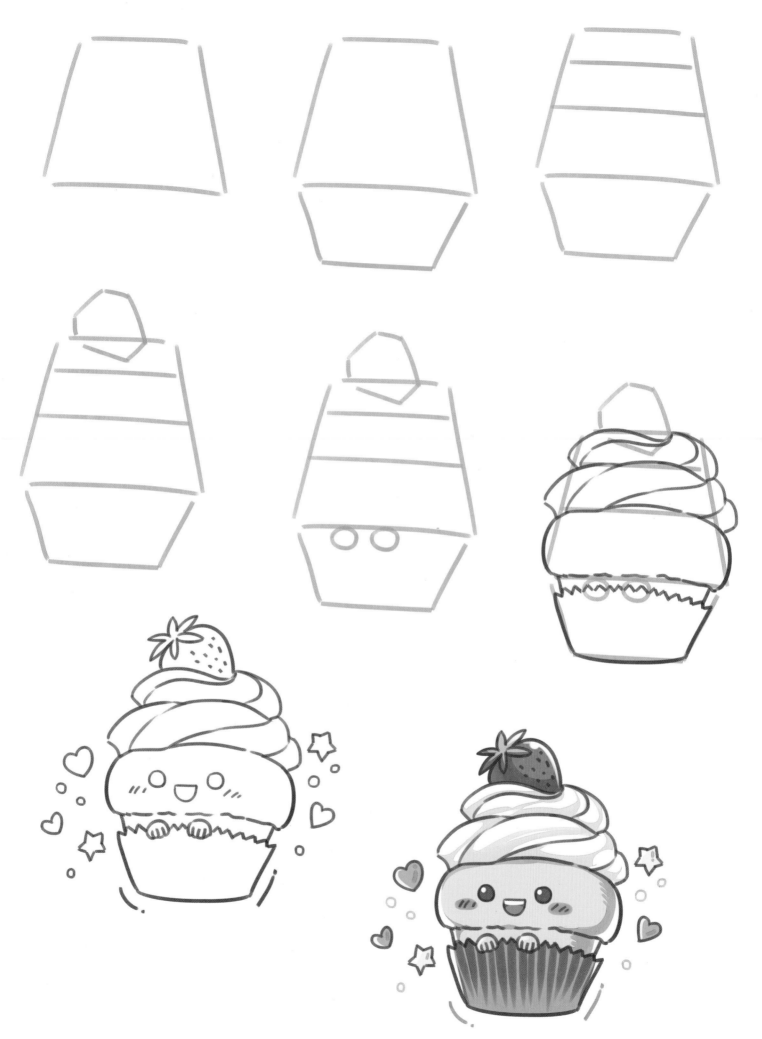

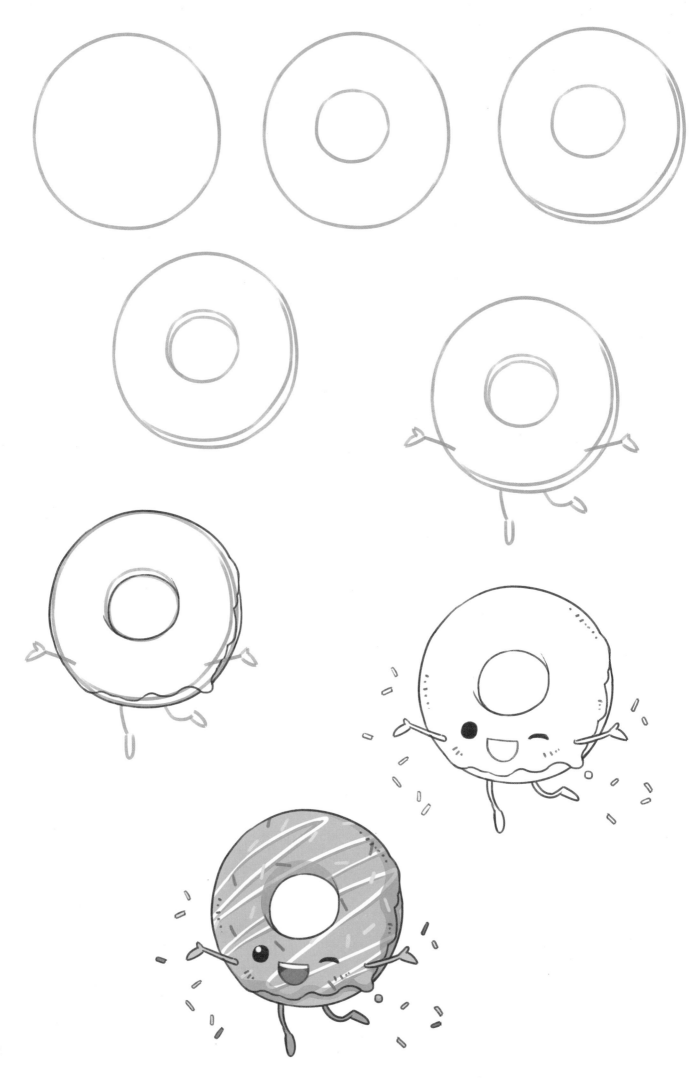

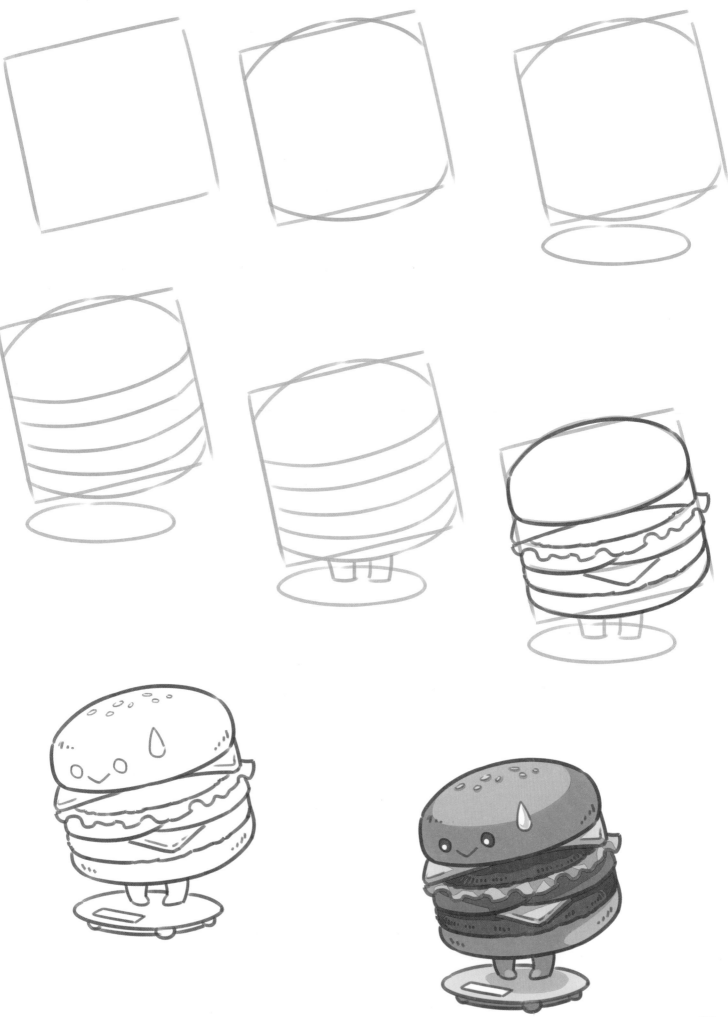

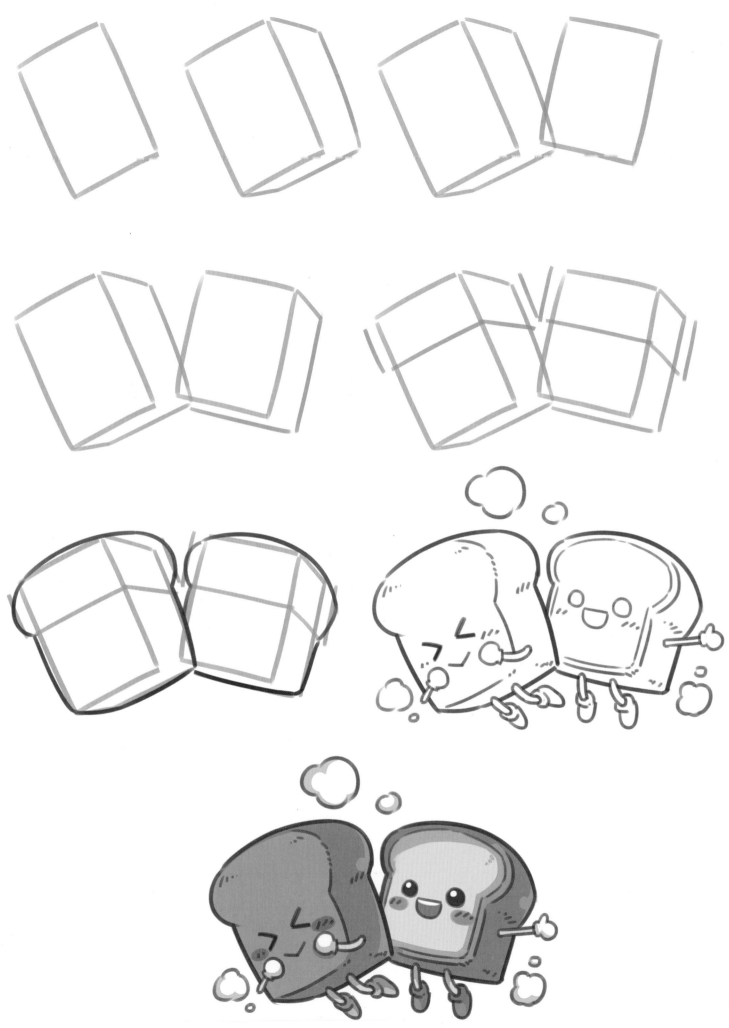

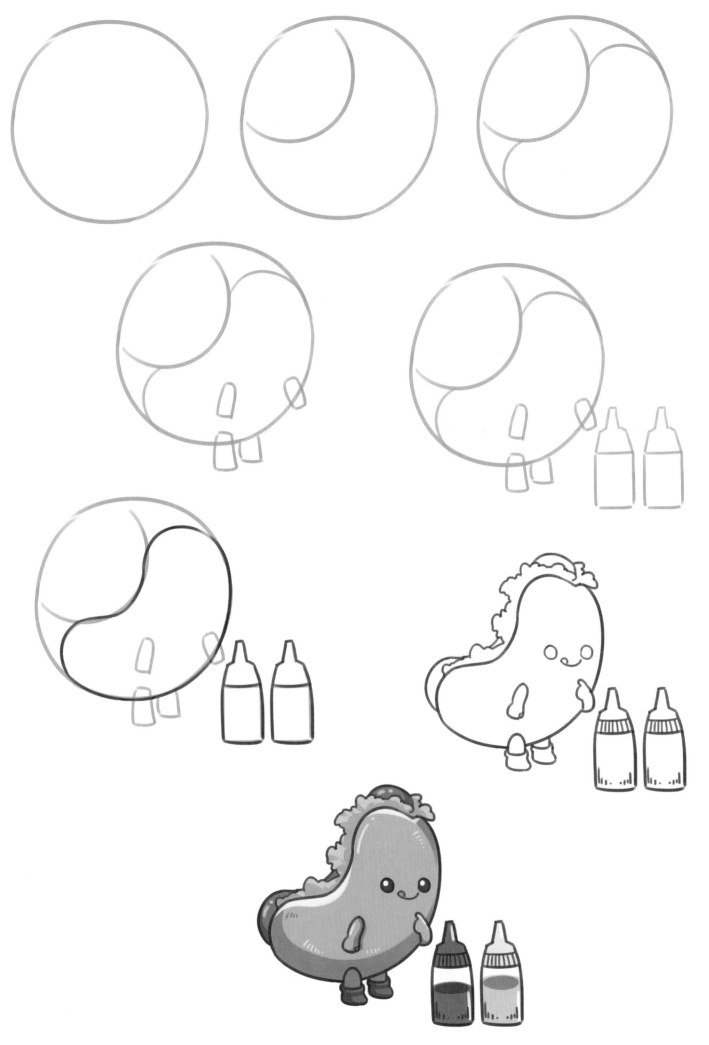

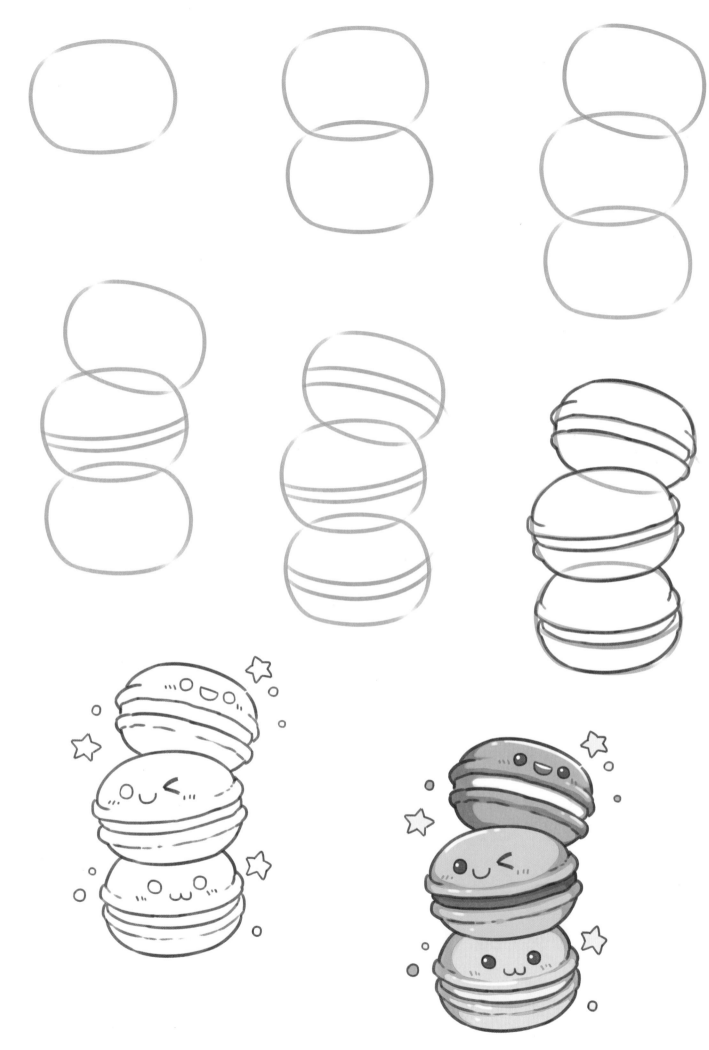

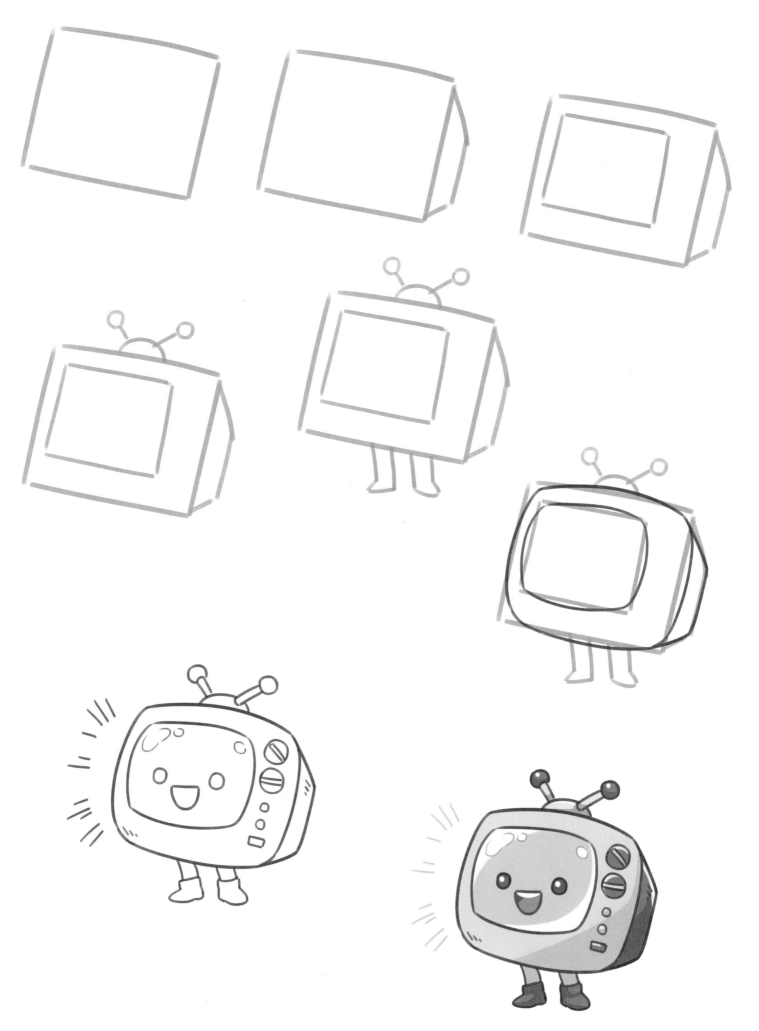

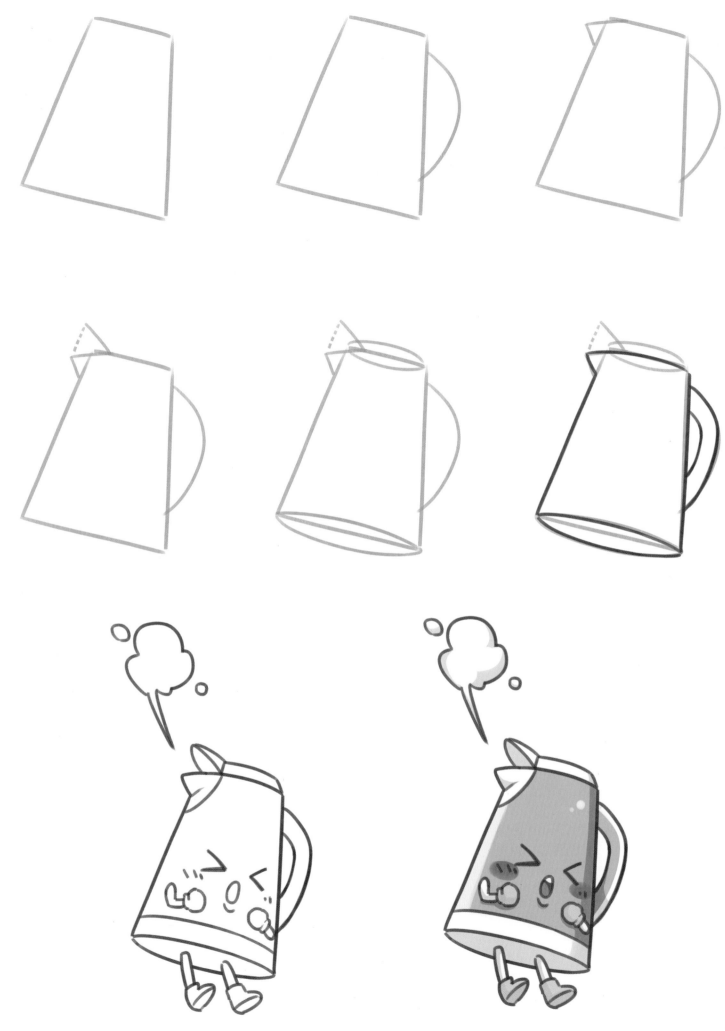

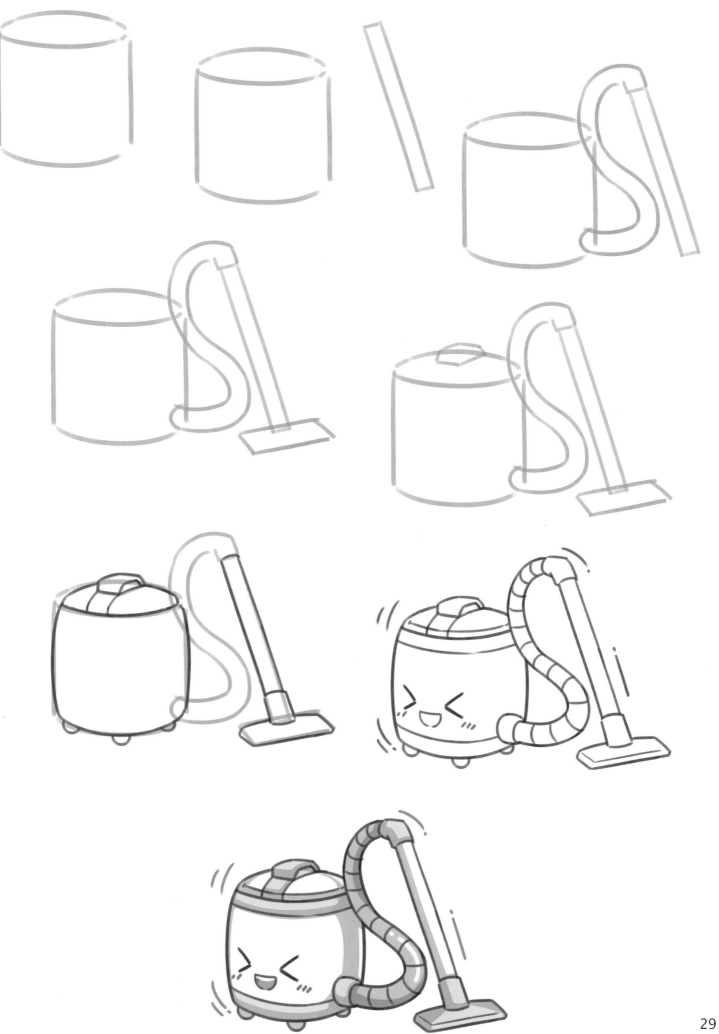

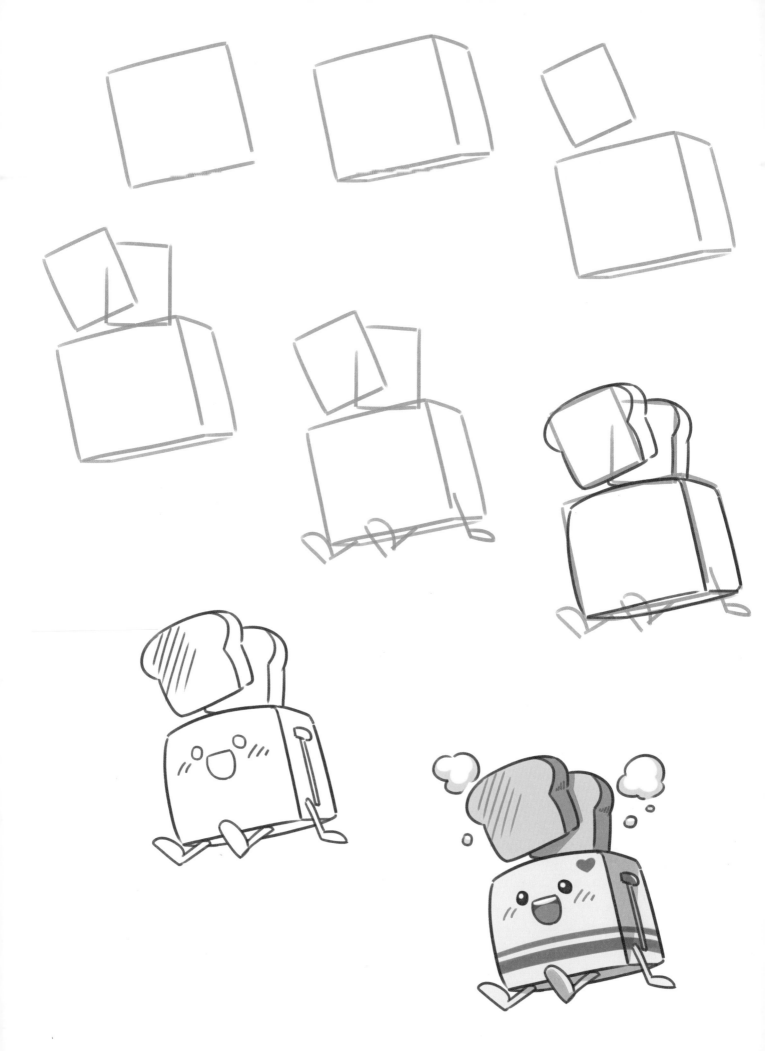

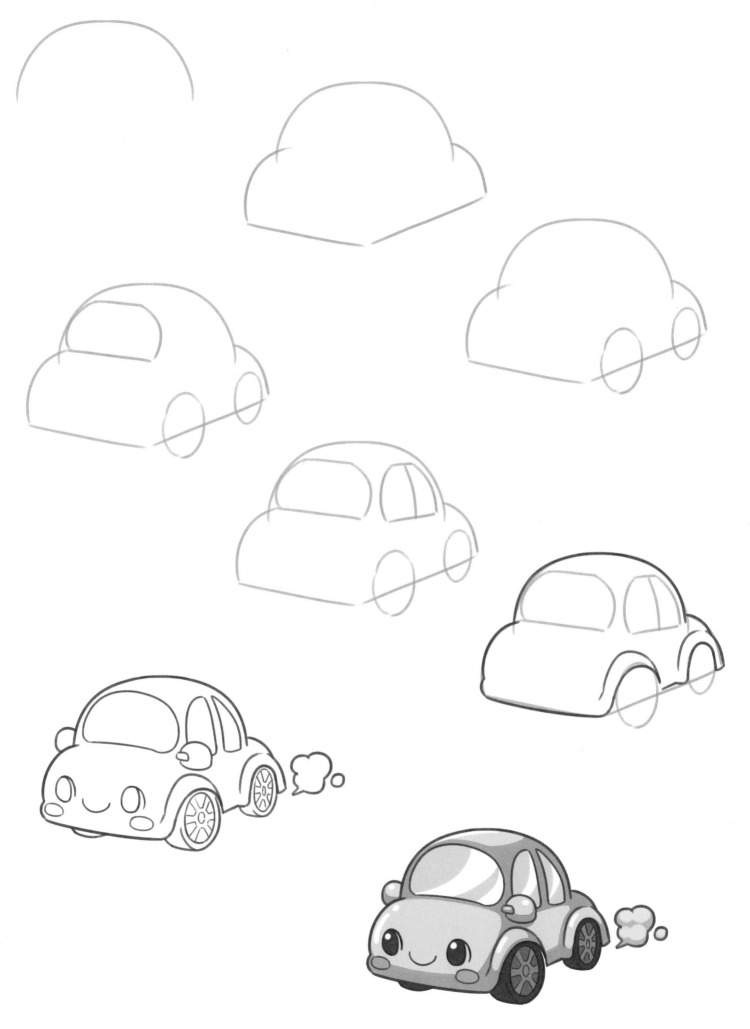

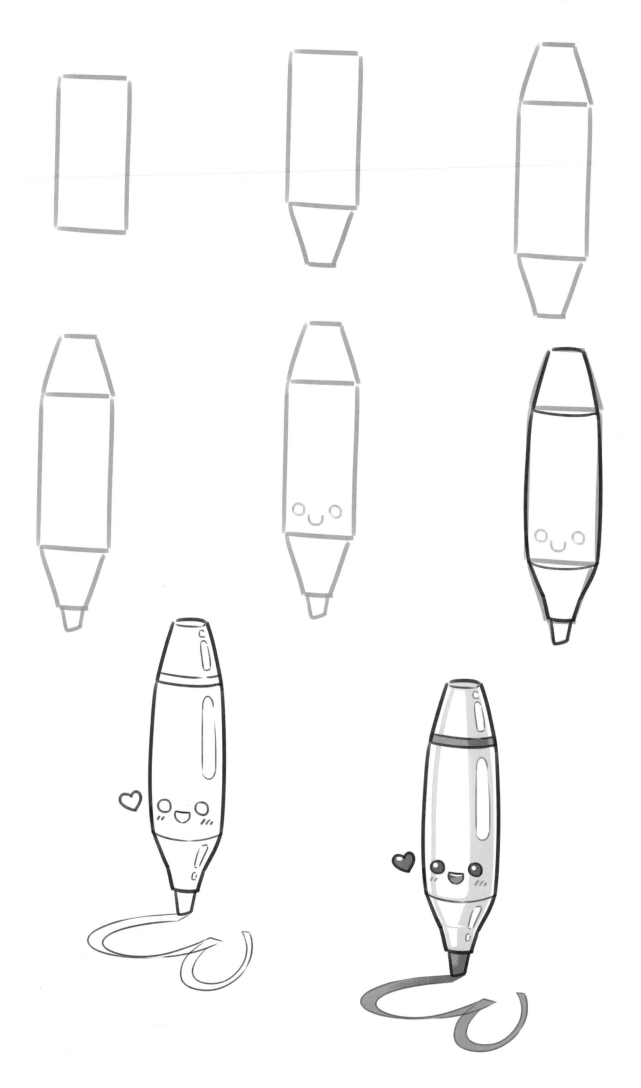